These Are All Words

These Are All Words

A Collection of Love Poetry

W. Ellingtone

authorHOUSE®

AuthorHouse™
1663 Liberty Drive
Bloomington, IN 47403
www.authorhouse.com
Phone: 1-800-839-8640

Published by AuthorHouse 03/14/2012

ISBN: 978-1-4567-8313-6 (sc)

CONTENTS

The Six Letters ... **78**

A Diary Of An Engagement **92**

I AM GLAD I MET HER

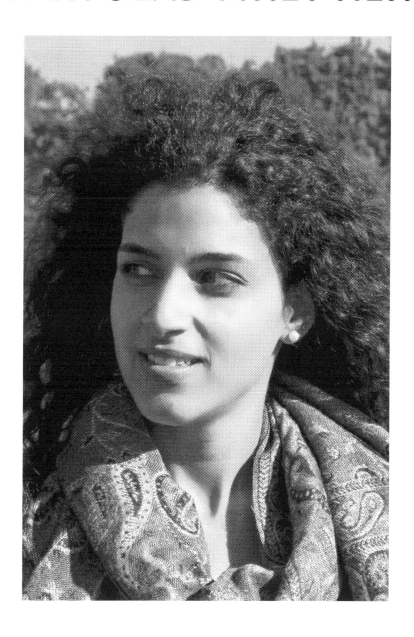

W. Ellingtone

A Picture Is Worth A Million Smiles

Beautiful such as you are
my butterfly I adore you . . .
the energy in your eyes is
a sight that tickles my senses . . .
i seem to stare at the walls
with hope that your image
will pour words of comfort . . .
i work the mind as sweat
trickle down on my forehead . . .
i find myself writing
another note to you . . .
lest i mention much
i am sure you tire by now . . .
words are better said
when kept inside thoughts . . .
forgive me gentle kind
mine is not lengthy a story . . .
i seem to stare at the stars
with hope that tomorrow
be a new and brighter day . . .
but time is so dear
and distance closes the door
though that said still . . .
a picture is a worth a million smiles

A Rose In The Middle of The Desert

*L*ike a teardrop on a baby's cheek
Your smile sparkles with enchantment
Sprinkling trifles of your scented breath
You magnify your warmth into the world
The paths you tread on have traces of kindness
You are a princess none have seen before
Yet modesty makes you servant to all
May compassion fill up the vacuum in your life
So that you may enjoy the best of each day
For yesterday is gone and tomorrow is forever
All I have are words but not ordinary words
They are for the praise of the Almighty God
For the magnificent works of his hands which
Sculptured *a rose in the middle of the desert*

W. Ellingtone

Good Morning To You My Dearest

Good morning to you my dearest!
I see that the sun has just risen and
I am extremely delighted to say,
You look utterly wonderful today.

I had a beautiful dream last night,
You were standing across a river,
I could see you were shouting dear,
But your words fell on a deaf ear.

Maybe you were calling out a name?
Maybe you were singing with the birds?
Whatever it is that you were telling,
The look in your eyes was compelling.

I am on my knees begging you please,
To tell the world that when tomorrow comes
And the tides begin to rise unexpectedly,
You will still be there smiling blissfully.

Enchanting Swiss

. . . Then, i opened my eyes
she stood right there
With her face erect;
i saw a radiant sparkle coming from those cute eyes
 . . . i dared not utter a word
yet, my heart pondered a thousand fold
i reached out to her but i stumbled
in between was a transparent wall
 . . . then i closed my eyes
and when I woke up, she had dissolved in the mist
i still wait but not in vain *I am glad I met her*
the ever-*enchanting Swiss*

Hold Me Forever

*W*hen I wake up each morning
my mind has clouded thoughts.

I lurch with unanswered questions,
unsolved puzzles and mysteries.

Thinking of you my dear darling
heals the pain of a lonely heartbeat.

You are a sensual
remedy, my sweet.

Your warmth has turned me fearless;
 when the world is senseless.

I never knew a love
so kind, yet cruel.

I have become a malevolent fool
as each day, I long for your sensation.

Quench me from the fire of passion
that is burning deep inside my soul.

Embrace me until I lose my breath and
nurture me like a falcon's nest.

Fulfill my quest;
hold me forever.

I Want You

I want you my princess and my flame
I want you in my castle this very moment
I want you to ignite my cave
I want your warm and sensuous smile
I want you to lay in my parlor
I want your silky golden hair to cover my bed
I want to pour lavender oil from your heard to your toe
I want to slowly caress your soft tender skin
I want to shower you with endless pleasure
I want you to go to places you have never been before
I want you to shout out words incomprehensible
I want to adore the path you walk on
I want to taste your cherry lips
I want to smell your delicious scent
I want you only you

In The Wings Of An Angel

Amazing she is, with a lustrous sight;
words there are none to describe.
How best do I portray such
an admirably adorned creature?
I fail to excavate the fossils buried
within the deepest part of my soul.
If only she could turn around when
she hears drums resonant in my heart.
She is as bright as sunlight in winter;
she indeed is an unblemished ornament.
Her pristine image glistens into my eyes;
her captivating smile dwells in my head.
She reveals that God is the master of artistry;
she is a gem King Solomon never had.
So when the sun sets the sky will glow;
igniting the beams of her electric smile.
At night, the moon will begin to shine;
as I fall asleep *in the wings of an angel* .

Picture On My Wall

I hang your *picture on my wall*
through out summer even fall
it makes me smile that is all

you stand there slim and tall
makes my head spin like a ball
how i wish i could give you a call

Red Haired Girl

Have you noticed red haired girl . . .

when you smile you close your eyes
that picture gives me sleepless nights

and i have dreams in the bright day
i speak when i have nothing to say
and continue looking up into the sky

you have the flavour that i like
heaven's jewel; yet to be mine
why can you and i not dine
and share a glass of red wine

It is just a thought red haired girl . . .

Sweet Joanna

\mathcal{S}hould I tell you what I know
I cannot keep this secret anymore?

My heart beats faster all the way
I dream of her each and every day

The story is about lovely Joanna
she is smart she is from Indiana

My mind keeps whirling like a ball
because I cannot be with her at all

I should tell you about her hair
that she keeps soft curly and fair

The sweet sound of her voice
makes me jump and rejoice

She is the girl I met in Montana
and her name is *sweet Joanna*

The Affectionate Robber

To love none other will i
> *she came to me like*
> *a phantom in the night*
> my heart leapt like a frog
> and all senses became numb

i felt like being conceived again
> such a feeling of despair
> none any human can confer
> i exhaled for a while
> when i opened my eyes
> my sense of feel was gone
> she vanished like a desert mirage
> In the midst of the night
> i searched and i found her not

now emptiness is what i hold on to

The Princess Of The Nile

she has dark curled *hair*
and the glitter from her *glare,*
*M*akes her beauty more than *fair.*

she tends to all my *pain*
in the sunshine or *rain,*
*B*ut in silence, I *remain.*

she showers me with *love*
has tenderness from *above,*
*S*o peaceful like a *dove.*

she is from another *world*
more precious than *gold,*
*A*n angel so I am *told.*

she one day will be *gone*
she will leave me *alone,*
A new day will be *born.*

she will vanish for a *while*
i will miss her soothing *smile,*
*T*he sweet princess of the *Nile.*

There She Was Again

I thought i would not see her for a while
but *there she was* with that same smile
her presence sent shivers down my spine
she intrigued me with that astonishing look
i felt like she was my long awaited love
a tormenting creature she was born to be
i looked into her eyes; my knees got weak
she was like a mirage in the desert
like a phantom in the darkest of nights
i closed my eyes slowly and sighed
hoping that it was just my imagination
but *there she was again* like yesterday
as real as the summer morning rain
my heart was filled with so much ardor
i was exploding with the desire to explore
beauty nobody on earth has ever delved
with passion for this mysterious goddess
yet *there she was again* melting away

These Are All Words

Your smile shines with enchantment
 like a raindrop bare in sunlight
 the freshness of your breath fills the air
 and magnifies warmth in the cold
 leaving traces of only kindness,
 you are a princess not from this world
 but a trinket from heaven's palace
 and a vanquisher of humility
 your life is full of compassion
 and your spirit is moulded from joy
 these are only words divine words
 there are all words for you my love

One Day One Moment

One day one moment, you were a revealed fallacy . . .
You were like a dream or maybe just a fantasy

I knew right from the start you were the finest . . .
Amongst all the stars you sparkled at the highest

You kept my heart beating day and night . . .
I felt the rhythm inside; you made me feel rude

I should be crying now but it's hard to let it show . . .
I should be trying again yet pride can't let it go

With time, I will learn to turn my desire away . . .
It will be a while to teach my feelings to obey

I am glad you let me borrow your smile . . .
And let my imagination run for a mile

Above all, you will always be a jewel of a kind . . .
Illuminating a light where no one can find

EMOTIONS THAT HE KNEW NOT

Achilles

𝒪n the times and the years,
right from the beginning of the end,
there lived a man of stature,
admired for his
courage and strength.

He was blessed with
the strength of a lion;
his enemies trembled
to the sound of his name;
his keen adored his footprints.

In the last great battle,
a thousand men tasted
the wrath of his sword.

The king drank to another reign
and the man's name was
sung for countless many years.

They say, before his death
he made peace with himself
when his ferocity was humbled
by her eyes.

His vile was pieced by
the tip of cupid's arrow
and his demise was
the birth of his legacy.

Brown Skin

Brown skin I knock on your door
 lady of earth please hear my call
 my queen I let the truth be told
 you are more precious than gold.

Brown skin I yell out your name
 but it seems you are all into fame
 I guess our logic is not the same
 or you think this is another game.

Brown skin brown skin please
 I beg you I don't mean to tease
 soon all my patience will cease
 and I will give you the freeze.

Brown skin I play it all fair
 yet I am less equal to your hair
 princess your beauty is so rare
 but your attitude shows no care.

Defiant Sensitivity

*h*e is a captive of his own thoughts
trapped deep in battles not fought
he shouts out words of all sorts
he sinks before he leaves the port

*h*is whole life is moulded into a vision
and time races fast without a reason
today is born tomorrow is a new season
as his dream has turned into his prison

*h*is heart belongs beyond the mountain
so he thirst till he reaches the fountain
for the journey is long sail on captain
this is a chance that comes not so often

Euphoric Emotions

Euphoric emotions are the ferry
that carry the sensation inside
I embrace a soft voice that
echoes at the back of my head
and dares to soothe my soul
but slowly I tire the mind
with thoughts I sure detest
my tongue is entangled by words
I know not of their connotation
Inside of me lay a time bomb
that implore for explosive passion
streams of tears trickle from my eyes
though I brave solemnly with a smile.

Forbidden Love

He is a gentleman I know of
I respect him like a brother
not that I care so much
it's his trinket that lures me

I found his treasure chest open
and there lay a precious jewel
so close to his warm heart
he would die if she were lost

I am tempted by *forbidden love*
a voice of reason echoing in me
to turn away from my desire
but her charisma weakens my will

now I hold her with my bare hands
she shines brighter than the stars
as I wake up from the long dream
I have to let her go back to his den.

Precious Confinement

A pearl in a shell is precious in all
but beauty exposed will tarnish by fall

Lest these words bring limitless pain
i come humbly to you not in vain

With desire to escape from all troubles
all is not lost but still the soul struggles

My oblivion is the excuse not vanity
my agony's remedy is thus divinity

A quest for sanity is thus arbitrary
trapped in thoughts, which are solitary.

W. Ellingtone

My Tears Drop And Vanish In The Rain

I am drowning in the vast sea
yet compelled to stay afloat

In denial with myself
i feel the hurt inside

with nobody to share the pain
only God Almighty knows my plea

I am waking up each day
to the empty sky

I see birds of all colours fly
nothing matters I am free now

But far above the dark clouds
i see mountains and valleys

My whole being floats like steam
as i draw far from all grim

The bold; the beautiful all the same
a laughter; a cry, and a lie

My tears drop and vanish in the rain
I wish I had loved you more

The Altar Boy

She had noticed that fine boy
 *w*aiting by the church door
he wore that wide smile
 *a*nd led her inside
little did she know
 *t*hat Jim was an *Altar Boy*
he looked saintly
 *i*n his white robe
she whispered in his ear
 *a*s he puffed the incense
showering her with blessings
 *a*nd as he got near
her face glowed like a firefly
 *t*wo years from that day
they would marry
 *i*n that very same church
and for sixty years
 *h*e wore that same smile
now she lies on her bed
 *i*n her last years
thinking of the good old days
 *s*he turns ninety-four today
and it would have been
 *h*er seventy-sixth anniversary
in the arms of *The Altar Boy.*

The Heart Of Troy

Bravery is for the wise;
the fools fall in love . . .

Of all the beauty of *Troy*
he saw none to conquer
but the trinket of a foe
he sought to entice

Buried in the midst of
devotion; all rational was lost . . .

Widows, orphans
and noblemen would fall
at the hands of this insanity . . .

But the sight of Helen
was a marvel worth the sacrifice . . .

Warriors would offer
their heads on a platter
just for a glimpse . . .

Queens of all earth
were burning with strife
for none had set eyes
on such a wonder . . .

But this rare jewel
would tarnish
the heart of *Troy* . . .

The Last Dance

\mathcal{I} waited for you
I watched the sunset
And listened to the
Songs of the forest . . .

I felt my patient wear
Minute by the minute
I looked everywhere
But there was no
Sign of you dearest

Only the winds divulging
My own foolishness
Even the trees laughed at me

You betrayed my love
And left me with no choice
But to trust no other
You left me in vain
Now all I feel is pain

I want to forget about you
And move on with my life
Somehow it seems easier
Said than done . . .

No matter where I go
No matter what I do
You will always have
A place in my heart . . .

So long my love
So long my friend
So goes the romance
So goes *the last dance* . . .

Twinkle Again

I picked a pearl
and it shined so bright
i kept it in my pouch
and kissed it everyday
it fell in the mud
and lost the sparkle
i polished each day
and wished it to glitter
i lost my patience
and threw it in the lake
each day i sit on the bank
and wish the tides
would wash it ashore
and if I could turn
the hands of time
i would never have let it go
and how i wish i could see
that twinkle for another day

Out Of Reach

My eyes lay open all the night
gazing eternally at the star far right
i pretend not to see the moon so bright

slowly I begin to lose this beautiful sight
my only determination is to kiss snow-white
but the voyage tires and confers me a fright

it is an old witch that gave her a bite
in a dungeon she is locked up tight
i'll unleash my weapon for a decent fight

W. Ellingtone

Smile A While

Smile a while
voyage a mile
say nothing vile
sail along the Nile
embrace and reconcile
be gentle not so bile
for that is now your style

Sword Of Comfort

For i shall sore deep inside
as my being is torn daily apart
i toil with no rest relentlessly
yet i wield none good of my sweat
a pact born of time and the wind
as agony waters my sanity wet
i listen to the purity of my soul
a voice shatters my will of silence
merely mysticism kindles from within
and serene devour with such violence
as the *sword of comfort* pierce life
my world begin to breathe some sense.

Wishing Well

I have travelled up and down the river,
climbed over the mountain,

And into the valley I slithered.

Yet I still do not know
where I am going.

Will I ever get there?

I do not know.
It is confusing.

But I have no choice.

My horse has lost track;
I will keep on riding though

Until the day I find a wishing well.

Woman No Cry

\mathcal{I} appreciate the life you gave me
and the pain you went through
you are my river, sea and ocean
your love is like an endless pit

\mathcal{B}ut, the perplexity you cause me
no connoisseur can do explain
you bury me in my own anger
and make me beg for your mercy

\mathcal{Y}et you are the base of my charm
The decency in me is your work
You nurture me with tender hands
And kiss where it pains the most

\mathcal{S}till this comfort is in episodes
the stimulation is only short-lived
i wonder why you torture me so much
i am a prisoner of your own pleasure

My head is a place of your dwelling
life seems meaningless without you
when you are in my life I am blissful
i become the king of comfort and joy

Then I dream of a life without you
and shut you out of my world
but the moment you step out
i hunt for you like a hungry lion.

FRIENDS OH THOU LOVE

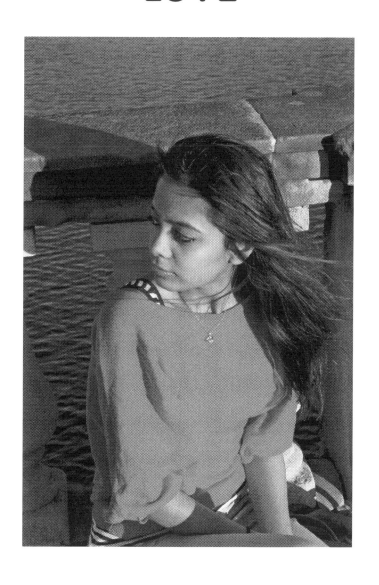

A Gentleman's Letter

𝓘 contemplate on this fine evening
not that I wish to utter words of such importance

Oh—gentle kind—of such a beautiful earth
how do so spend the day in this magnificent city?

I probe the state of her health
and compliment on such hospitality
for every pair of feet that lands in her home

I fear that this opportunity holds me accountable
I show not adequate gratitude
as that required of a fine gentleman

I marvel with admiration of her warm heart
her eyes glow; her smile silence commotion

To say the last I do care not worry
it is her patience I notice
I retire knowing that morrow waits
the bright rays to reveal her flamboyance.

A Thousand Miles Across The Ocean

I hope I find you with a beautiful smile on your face
And that this note reaches you before Christmas
I have not stopped thinking of you ever since summer
Thank you for the beauty you left behind
I know you carried the best part with you
The strong bond we have created overwhelms me
I hope this great friendship will blossom like a daisy
I am happy to have known you in this life
I do hope you have a fruitful time
And wish you well in your future
I wish you kindness and good health
I have enclosed a small present
And hope you will be thrilled
Do not ever forget that you have a friend
A thousand miles across the ocean

Count On Me

I have found a friend in you,
that makes me smile till dusk
neither now nor then will we part,
a fine pair we so do make
it was written before we met,
two souls be known as one
this is not love at all,
this surely is insanity
an unfathomable union;
i be your guardian angel,
you be my fairy godmother
together we will travel
the world on a magic carpet
let me protect you
from your demons,
until the little light
in you twinkle again
you are not alone anymore,
you now have a special place
i will sing your trouble away,
and kiss you where it pains
i will be your knight my princess
until the moon starts to shine,

and the stars start to fall
you will learn the kindness of love,
and bring out that sparkle again
if this world should forsake you,
count on me till the end of time.

Emblem Of The Last Cupid

I am the fountain of adulation
a sanctuary of sensual devotion

I am the epitome of soothing emotions
and a genuine trace of sensitivity

I am the ignition to the candle flame
an extinguisher to the burning soul

I am the resurgence of fading zeal
and the *emblem of the last cupid*

Postcard

I send this postcard
>that i wrote yesterday
>to tell you that
>you are the only girl
>i have ever loved.

I send this postcard
>just to say to you
>i am thinking of you
>thousands of miles away
>from dawn unto dusk.

I send this postcard
>to tell you that
>last night i painted
>a picture of you
>it hangs on my wall.

I send this postcard
>> to remind me of
>> how beautiful you are
>> how i dream of you
>> each night i go to sleep.

I send this postcard
>> so that you can recall of
>> my admiration for you
>> and my long lasting dream
>> of being in union with you.

I sent this postcard
>> because it's my only way
>> into your secret world
>> so that you can know
>> where i am coming from.

The Colour Of Love

The sunset glows flamboyantly golden
the skies are adorned with delicious blue
how lovely is the shade of the rainbow
but the *colour of love* i fail to envisage

the bride is gaudily clothed all in white
blue for a boy and pink for a sweet girl
every occasion has tint enrichment
but the *colour of love* is not defined

love is in the air so red roses it shall be
it's night time romance prevails in black
the candlelight is illuminating the silver
but the flames show not the *colour of love*

red is also the flavour of fresh strawberries
brown roast beef with rich green broccoli
an enriched shade for the appetite in me
but what is the *colour of* this tasty *love*

this must be love with a scent so sweet
my body is in pain my mind in disarray
as i ponder and search for an answer
what *colour* encrust this exquisite *love*

The Beauty Of Mother Nature

A pair of eyes lost in oblivion
gaze with delight the beauty of her
mother nature; how sweet such divine
all living she embraces with a smile
they marvel they sing beautiful hymns
her garment so green she dresses
despite her blue hat with white feathers;
a fresh breath of life begins this moment
"fall in love", she says, with a dense look
but surely be home before midnight
lest you turn into a pumpkin

Tick Tock

A flake of snow falls
Lightly on your cheek
Your pure face glows
Like the sun above the peak
My dear did you know
Your smile makes me weak
Please open the door
When I knock and seek
Let your love flow
Into my heart humble and meek
It don't matter how slow
Can be a minute day or week
I won't let you go
I will let the clock tick.

DANCING DREAMS

Belly Dancer

*M*y emotion sails across the seas
To a land unknown to my fears
It follows an exotic fragrance
Spurting from her rich essence

She magnifies my joy and sensation
I am in awe delight and jubilation
Though I am in woe with a delusion
Her comfort is my only recreation

When days are long and weary
I will make a wish to this fairy
My quandary she will solely bury
The *belly dancer* I wish to marry

Ballerina

I saw you and smiled
but i did not say anything

your glowing eyes blinded me
into another world i was

the sound of your voice
trembled in my ears

you tortured me with your gaze
and set the moment ablaze

like snow on a sunny day
my heart melted away

dance with me *ballerina*
send me to another planet

let me taste the flavour of your love
and smell the scent of that passion

Fly High

Fly little bird, up so high
float on the fluffy clouds
flow with the rain in the sky
feel the wind lift you up
flatten those wings in the air
face the high mountains
far over the deepest ocean
faze your light feathers
free from pain and strive
frisk with cupid in a circle and
fall in love with her melody
fill up the heavens with harmony
flirt with the beautiful angels
forbid not this to be your time
for this be the joy of your life

I Write This Letter

I Write This Letter to you
as I toss and turn all night
hush thoughts entangle within
and I contemplate a chance gone
it could have been charming
but I wasted too many words
it was not easy to let you go
and now all I wait for is thin air
I am glad to write this note
hoping for a super miracle
in a way this is my farewell
I will watch the sunrise with faith.

Insomnia

Then you wake up
and take a deep breath
you see me in a dream
here with you
you are sweating endlessly
you feel like jumping
out of your skin
you are overjoyed
and your heart
is about to leap out of your chest
you cannot close your eyes
your lips tremble
you feel my warm tongue
curling on yours
your body is shivering
you feel like your whole self
is about to erupt into a raging fit
and you cannot feel your toes
then you scream out
then your essence subsides
and drifts off far away.

W. Ellingtone

My Forever Love

𝓘 say it with champagne and candlelight,
beautiful carnations a smile with delight

A warm kiss and the most gentle of touch,
only my actions speak I need not say much

My words to your heart are gently lethal,
with energy that ignites a night so special

You flatter my senses with fondness so kind,
such comfort nowhere in the world I can find

Your passion haunts me like a bad dream,
and I quiver briskly like a turbulent stream

I feel that passion burning beneath my heart,
though the oceans still keep us further apart

I will cherish you each day night and forever,
in laughter in vain no matter the weather

May your patience be my virtue and gift,
hold my hand far from you I will not drift

You are sweet like honey from the mountains;
you are refreshing like water from the fountains

Such tenderness can simply be from above;
my dream is for you to be *my forever love*

W. Ellingtone

The Dream

It was all gone in a second
that long awaited sweet dream
the wait and the anticipation
all gone like the summer rain
it never did occur to her
that the end would be a tragedy
pain that hurts like a bee sting
it had been nothing but a fantasy
all the dreaming and believing
added all up to empty faith;
she built her castle in thin air
the winds came and blew it away
but she will need to be strong
the **L**ord is still by her side
He will be with her till the end
she can hold on to *the dream*

The Reality Of A Dream

So many nights unbearable
i detest to sleep; i toss and turn
on the very thought of you

i am confined amid four walls
they laugh at me; such is my pain
of this long unending dream

with a smile on your face
you walk to me as i run to you
like a vicious hunting leopard

the moment you are in my arms
i am fully awake but the reality is
you are not here with me at all

THE WORLD IN LOVE

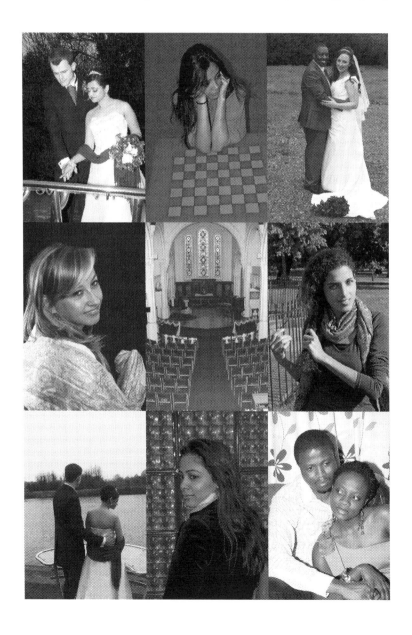

Africa—The Queen

*H*is ardor is the precious gift he brings
to quench his thirst from the spring.

A hundred miles away lay a throne
the ride is long, yet he has not forgone.

He comes to adore a being born for all
a stunning goddess with a golden soul.

He will dance to the tune of her laughter
and will lay down his sword right after.

But he wishes for what might have been
if only he had met *Africa—the queen*.

America—Magnificent & Sweet

Oh *America*; beautiful *America.*
 you are so *Magnificent & Sweet*
 you make my laugh
 you make my cry
Oh *America;* how I adore you.
 i want to kiss your strawberry lips
 you have the body of a goddess
 your eyes sparkle like diamonds
 your smile brightens up the world
 i love everything about you
 your nicely curved breast
 your juicy and flawless behind . . .
 fill my nostrils with your scent
 i want to be intoxicated by love
 i want to stroke your silky hair
 and feel your smooth olive skin
Oh *America*; you are all of it all.
 i have dreamt of you often
 you are all i ever wished for
Oh *America*; lovely *America.*
 i want to lay next to you
 you are all i want
 i hate you and i love you
 i want to come into your world
 and lay next to you eternally
 blow away my senses
 and send me to the moon

Dance with me; Oh *America.*
 teach me the old rhythm
 let me test your melody
 till i sing in harmony
 how i wish i never knew you
 for now, mine are sleepless nights
 you have drained my energy dry
Oh *America*; beautiful *America.*

Arabia—My Heart

My heart hangs on a cliff
I need heavens to believe
Each day I crave relief
From a world of deceit

My heart received a shove
I long for peace like a dove
I am just a virgin to love
My only joy is from above

My heart is thus torn apart
Since *Arabia* decided to depart
I think I need a fresh start
It took a while to know that.

Asia—Forever

*M*y lady;
I marvel your humble grace
your pure heart a precious emerald
you shine your light on the meek
your strength is food for the weak.

I am delighted that you lost your wings
for my soul would starve
should you fly back to heaven
you are a goddess amongst all goddesses,

and

I long to kiss the ground
you tread on each day
your silky hair long and dark
follows the contours on your body
and when the easterly winds blow
it waves goodbye to the young and old.

How sweet is the sound of your voice
ringing bells of melody right in my ear
and the glow in your exquisite eyes
says a language only divine.

I cherish your presence now and then

Asia;

Forever I'll miss your fragrance.

California—Enchanting Gaze

She is sitting right by my side
speaking so eloquently and confidently
heaven must have dropped her from above
for now i know what angels look like
she is living proof that they exist
when she smiles you will get thinking
that the world is such peaceful place
blessed is the king and the queen
who created such unimaginable beauty
may she find happiness and kindness
she is the princess of comfort
she has an *enchanting gaze*
i can feel the warmness of her heart
such tenderness is from the Almighty
but i fear that she will fly away
lend me wings I want to flutter with her
to the alien world i don't care
mine are only words for *California*

W. Ellingtone

Canada—Miss Daze

Hey miss daze
giving me the gaze
you put me on blaze
i am all in a haze
let me sing you praise
to fill you with craze
it's the last phrase
on these final days
we go separate ways . . .

Espanola —The Light

Then i met a senorita
her name was Carmen
she had a smile
as big as the ocean

she had the life
she had the light . . .

she was the hope
and i was the man
i became faithfulness

i became the light . . .

i know i hurt her
i know she cried
to be fair i tried
now i feel divine

i have found the light . . .

Gambia—Joyous Moments

*I*s comfort the beauty of modesty
or is love all we hope for in life
this affection has turned into agony
breaking my bones and my soul
my vision is blurred with sadness
wisdom has vanished from my world
and foolishness has clouded my path
i try to fill my mind with *joyous moments*
but long memories of my lost passion
still block the light to any kind of hope
i miss the magnificence and contentment
the joy stolen and the years of delight
so fly your wings high angel of **h**eaven
show your radiance in the path you tread
i will nurture thoughts of you forever

India—The First Ray Of The Sun

The morning bird is singing
darkness bids farewell
as she raises her head and
looks straight into my eyes
i am dazzled with such beauty
miles away my mind is blown
only her smile speaks words
that are serene to my senses
she is the answer to the riddle
i could not solve in my lifetime
she is—thus—my dawning light
when the earth is in darkness
craving for a brighter day
she is; *the first ray of the sun*

Jamaica—Princess of Comfort

The long beautiful morning
and the awe—inspiring sunset
match not her magnificence;

she has the eyes that sparkle
like two dear diamonds on
an undiscovered island;

she is the princess of comfort
and when she smiles even
the brave tremble with delight;

a thousand words cannot
best describe her whole beauty
as she is only; she is my *Jamaica*

Liberia—O blessed

From miles afar i smell the beach
there she lay all in white
with a breeze blowing her curly hair
as the sunset turns her eyes into gold
she smiles the world turns beautiful
i waited until today
to witness kindness
and sweetness conceived
happiness is all i wish for
Liberia—O blessed

Macedonia—See You Tomorrow

I stopped writing love songs
but i still sing the blues
i have done many wrongs
so let me tie my shoes

the streams have run dry
yet again i drown in sorrow
and the time still goes by
i hope to *see you tomorrow.*

Persia—Transient Dreams

She is still taking it all in
her hands shake each second
her mouth is bone dry
all her limbs have gone numb
she hears his voice over and over
she is entangled with disbelief
life sure has its moments
one minute you laugh
and the other you cry
does she deserve it
it doesn't matter any more
she is glad her heart survived
though it will be a while
to put the pieces together
to have loved someone
a dream fulfilled with no regret
what matters is what's left
the cream walls of her lounge
she sits and looks at the clock
time seem to go by
tick tock tick tock
yet the minute hand
is stuck on nine
the moment she received
the stinging words . . .
words that crush
a strong woman to pieces . . .

Persia—Hard To Say Goodbye

. . . .She feels like her toes
are stepping on broken glass
he sat there on the coach
and told her
she had a pretty smile
he said he would never leave her
but now she stares on the wall
all she has are words
with a cold bite
she is engulfed
by empty promises
her head aches each second
nothing better than having him back
but her willing to part with him
will be her strength to move on.

Venezuela—Sweet Cherry

I tire from this song
make me feel strong
i know i did wrong
i need now to belong
my tears have dried up
my fears have subsided
my heart is still beating
i'm taking a deep breath
i try to close my eyes
i see your virtuous face
and reminisce the time
you and i were one
you tell me goodbye
is this the last kiss?
you will always be
my *sweet cherry*
oh my *Venezuela . . .*

Zambia—I Care

Though you may be far away
your image dwells in my mind
your scent is in the coffee
that i drink each morning . . .

every night when i go to bed
i lay still with my eyes open
then i see your body on the wall
an enthralling site you are . . .

the blind feel your face glow,
like an angel from above
and when you throw your smile
i feel its gleam within my soul . . .

words i have none to say
you have heard them all
love is all i wish for you
To say the truth, I care . . .

THE SIX LETTERS

Cornelius—The First Letter

*W*e were young and yet so beautiful
our hearts belonged together
i could never dream of anyone but you
i felt strong when i was with you
the long walks on the beach
the colourful sunset ; *Elaine*
the sweet scent of the morning rain
what went wrong my dearest
all i wanted was to love you
my desire was to explore your tenderness
something got in the way of our devotion
i still cannot solve the puzzle
unanswered questions still cloud my mind
who was to blame?
it does not matter anymore . . .

Elaine—The Second Letter

I remember the time when nothing else made sense
i never thought that love could be so kind
yet i could not stand the pain it inflicted in me
i wanted to believe everything you said,
but nothing made sense
i felt like the world was falling into a pit
i adored you;
you had been my sunshine in winter
yet i could not look into your eyes
all my trust had drifted away
i had so much anger
but it was not possible to hate you
this ache i could not endure
i had to leave, can't you see . . .

Cornelius—The Third Letter

*W*as it what i said or what i did not say
i never meant to hurt you
all i wanted was to protect you
could you not understand my dilemma?
the dream i had to fulfill; the love for you
I had to choose between my left or right eye
yet, i needed both eyes to see
i apologise for what i did not do
i still cannot describe the pain i felt
when i watched you walk away from me
how i wished it to be only a dream
you vanished like the morning mist
and never gave me a chance to explain
anger made me say the wrong words
i could not bear living without you . . .

Elaine—The Fourth Letter

You caused me so much pain,
but you were not entirely to blame
i guess we all said what we did not mean to say
i was angry at the world more than at you
why did this have to happen to us
everything became complicated
i never meant to walk away from you
i just could not stand the agony
though we were from different worlds
we shared the same passion
for an everlasting love, until death do us part
i watched the sunrise and the sunset everyday
hoping to find some clues somewhere—somehow
you were the only solution to my insecurity . . .

Cornelius—The Fifth Letter

\mathcal{S}anity within me vanished
as the thought of losing you was bewildering,
it was not only your beauty i missed
but every tiny bit of you;
the smell of you,
your stunning long hair,
your feet, your toes, your nails
i felt incomplete without you
nothing mattered anymore
even the sound of the birds made no sense
i cannot describe the feeling
when i saw you leaving
my father told me, *man don't cry*
but when you left me
being a man meant nothing at all . . .

Elaine—The Sixth Letter

*Y*our were so kind to me
yet i treated you with malice
all i could ever think about
was to be with you
you made me discover
what no other woman could ever know
you were my knight,
my fairy tale,
the way you held me in yours arms
made me feel so complete
hold me now; *Cornelius*
chain me to your heart
put me in a cage like a bird
and do not ever let me fly away again
you will always be my shooting star . . .

A DIARY OF AN
ENGAGEMENT

Monday—Infatuation

What a delight that i receive
 such colourful words on
 this fine morning, thus starts
 my day in such an ignited mood . . .
 i send my gratitude for being a
small part of your intriguing thoughts . . .
i will be thrilled to know that
you are putting on your magnificent
smile at this very moment, and
you look forward to being
part of this cheerful day..

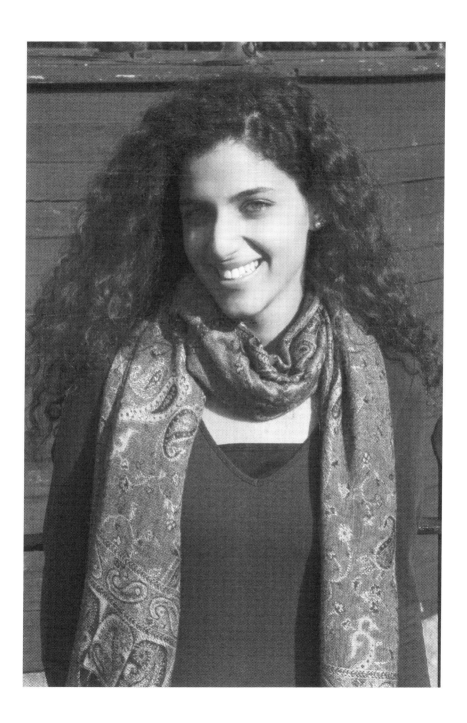

Tuesday—Revelation

How enchanting my lady;
 indeed how delightful . . .
 i stand outside as i pen this note
 a cold breeze sends shivers
 to my skin yet i feel not
 the wrath of coldness,
only that warmth you talk of . . .
i am still at loss for words for i do know
how you were able to send the
warmness in the exact place i stand . . .
not to dwell on that; my day
was rather calm yet enlightening,
i take it your day is one to talk about . . .

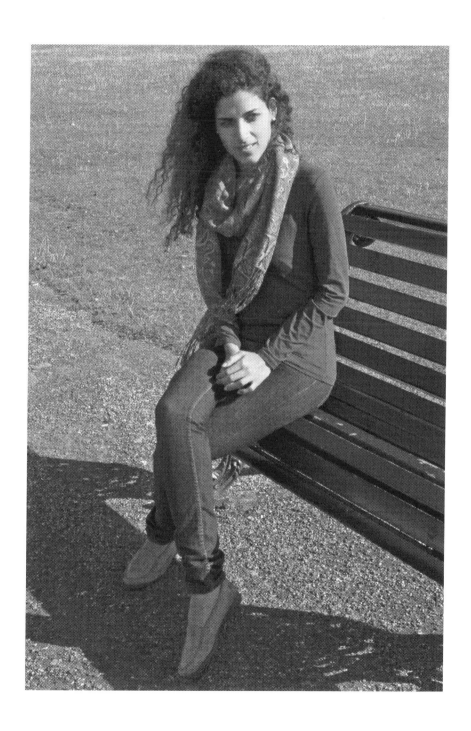

Wednesday—Anticipation

Where thou art my lady
 for i feel lost in the wilderness . . .
 a quick word before you embark
on your awe—inspiring journey . . .
i feel disenchanted for
i never said goodbye . . .

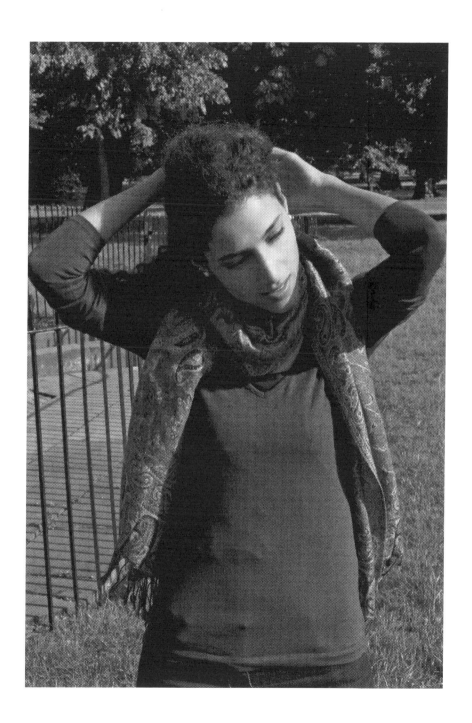

Thursday—Delusion

𝒯he saying goes,
 it's the thought that counts . . .
 the mere fact that you still had
 this poor gentlemen in your
 thoughts even when
 exhaustion clouds your mind
 is in itself exhilarating . . .
 thus, i send you such great gratitude
 and so till dawn shows its rays . . .
as for my health worry not
for i think it is a little matter
that does not need consideration
but i do thank the immaculate
lady for showing concern . . .
to say the last i do well
i hope your dreams are kindly . . .

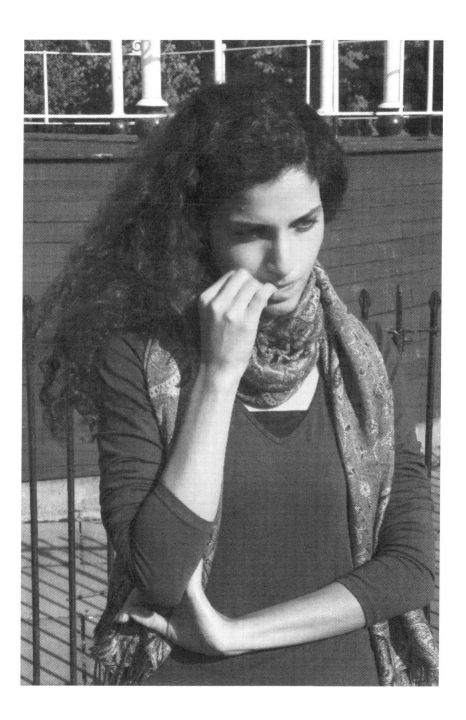

Friday—Reverie

\mathcal{S}uch a pleasant surprise
 that i still have the privilege
 of receiving a note from you
 even though we had said goodbye . . .
 my day was filled with comfort
 of your voice resounding in my ears . . .
 all of a sudden a week has turned into a year
 though i think less of such now that you have
reminded me that you are only still a mile away . . .
i will not say goodbye for i do not know if *Santa*
might bring me an early *Christmas* gift . . .
i might just receive a knock
on my door and there you
will be standing dripping
wet from the rain . . .

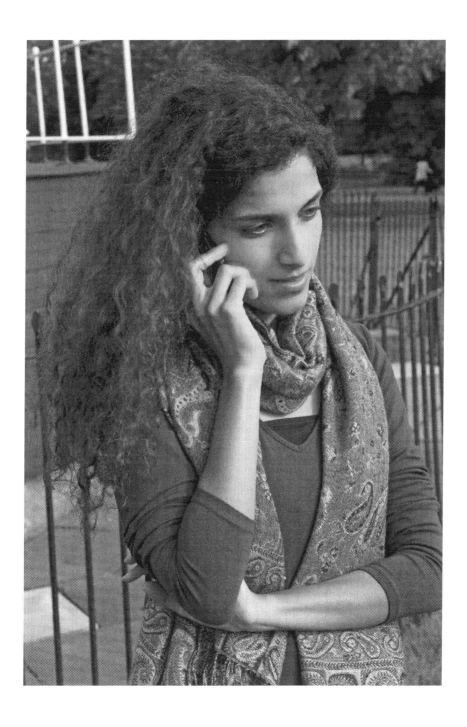

Saturday—Wondering

Where is the hopeful lady of my earth
 for this taunting silence makes me
 wonder what has become of you . . .
 i try to worry not
 yet i cannot help it
but assume that undesirable fate
has come your humble way . . .
i seek your confirmation that
you are in good health and hope
your day is filled with sweetness . . .

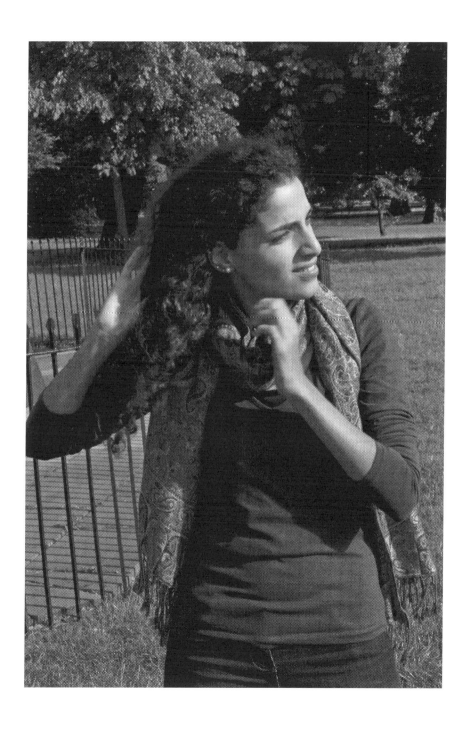

Sunday—Beautiful Morning

Beautiful morning shine
 your golden rays into her eyes
 ignite her tender face
 and let it glow
 with an enchanting sparkle . . .
 let her hear the echoes
 of a searching voice . . .
 how sweet thou art
 when she smiles
 and soothes the turbulence
 of a lost mind . . .
 she is like a herbal remedy
 running through the veins
 of a craving soul . . .
 her heart is a prison of passion
 waiting to break free . . .
 she lays in bed each night
 with questions unanswered . . .
 her eyes elate
 as she seeks to unfold
 the enigma that haunts her life . . .

Beautiful Morning; let her know
 that she is not alone in this voyage . . .
 tell her there is a spring
 in the middle of the desert
 where she can quench
 her agonising thirst . . .
 where she can wash
 her silky hair with honey syrup
 and let it dribble down
 the contours of her body
 and bare skin . . .
 let her smell of the sweet exotic
 richly floral scent of jasmine oil,
 and let her wake up from
 this dream with elation . . .

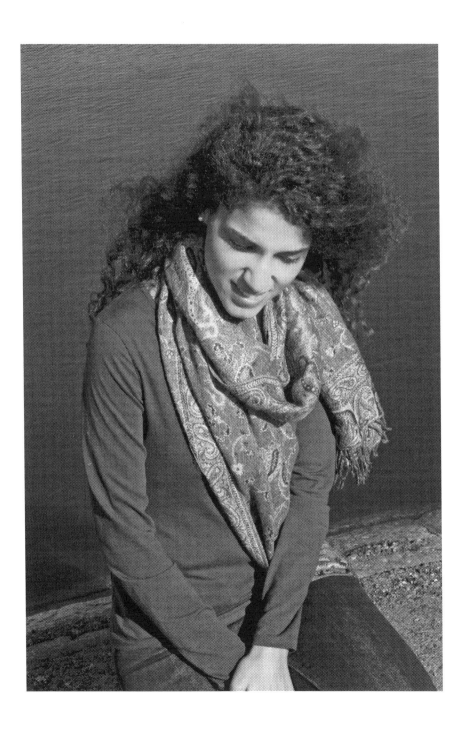